# AWESOME
# Animal Designs

## Kelly A. Baker
## AND
## Robin J. Baker

DOVER PUBLICATIONS, INC.

Mineola, New York

# NOTE

This fabulously funky coloring collection includes caricatures of animals, birds, and insects accompanied by abstract patterns, geometric shapes, or psychedelic swirls and spirals. The detailed designs provide a challenging coloring experience for artists of all ages, and the unbacked, perforated plates make it easy to display your work.

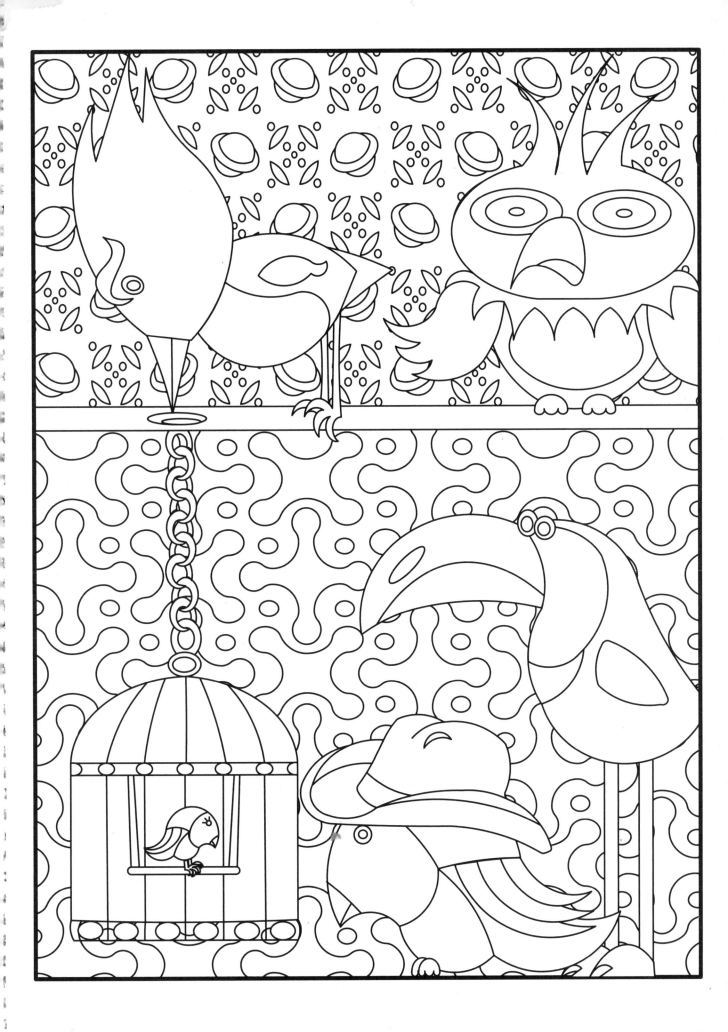

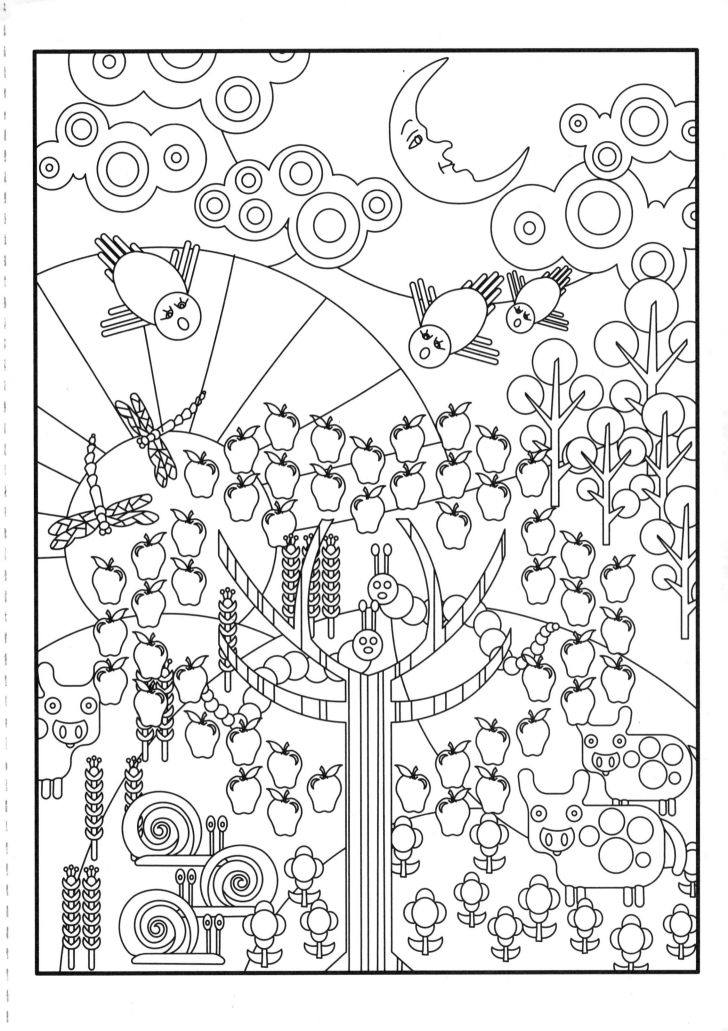

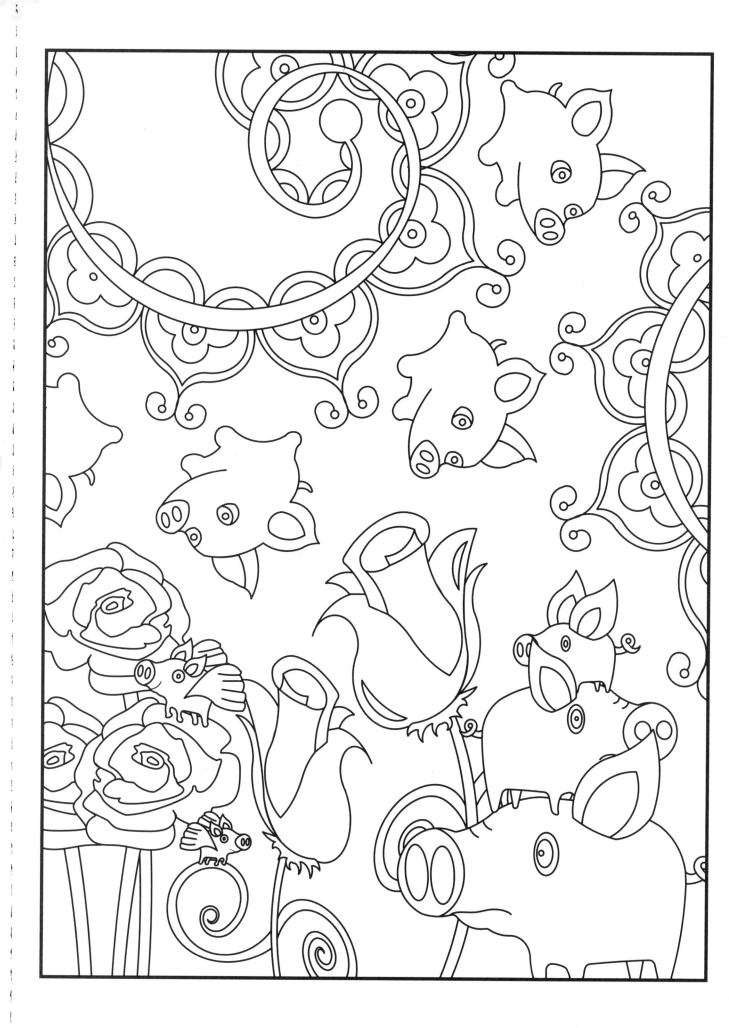

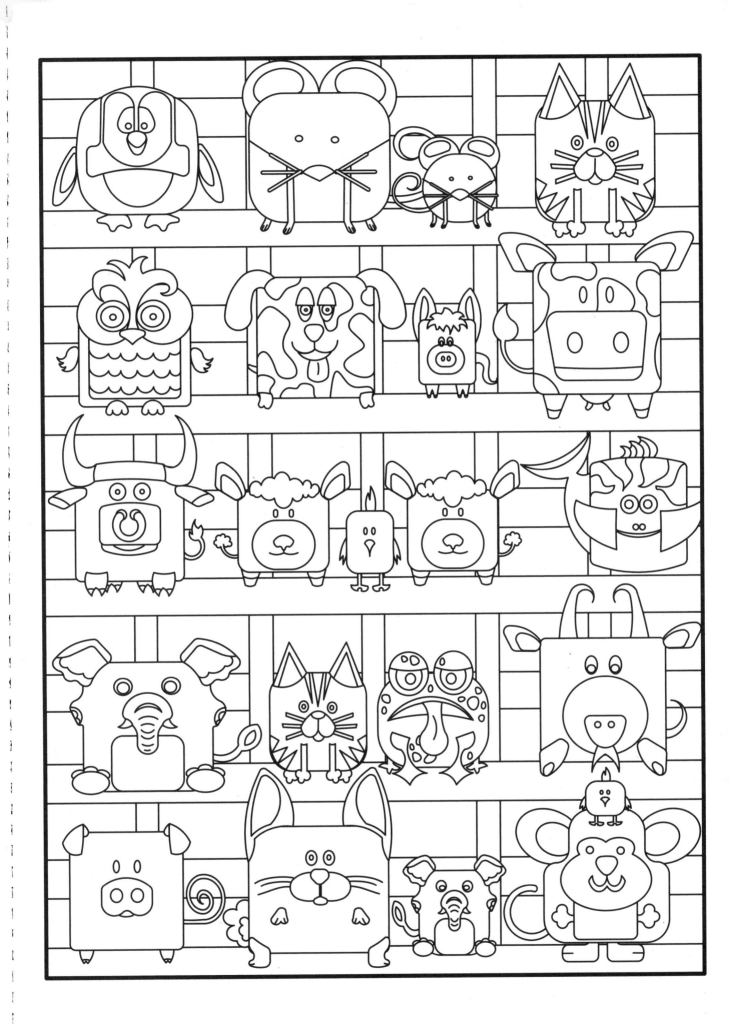

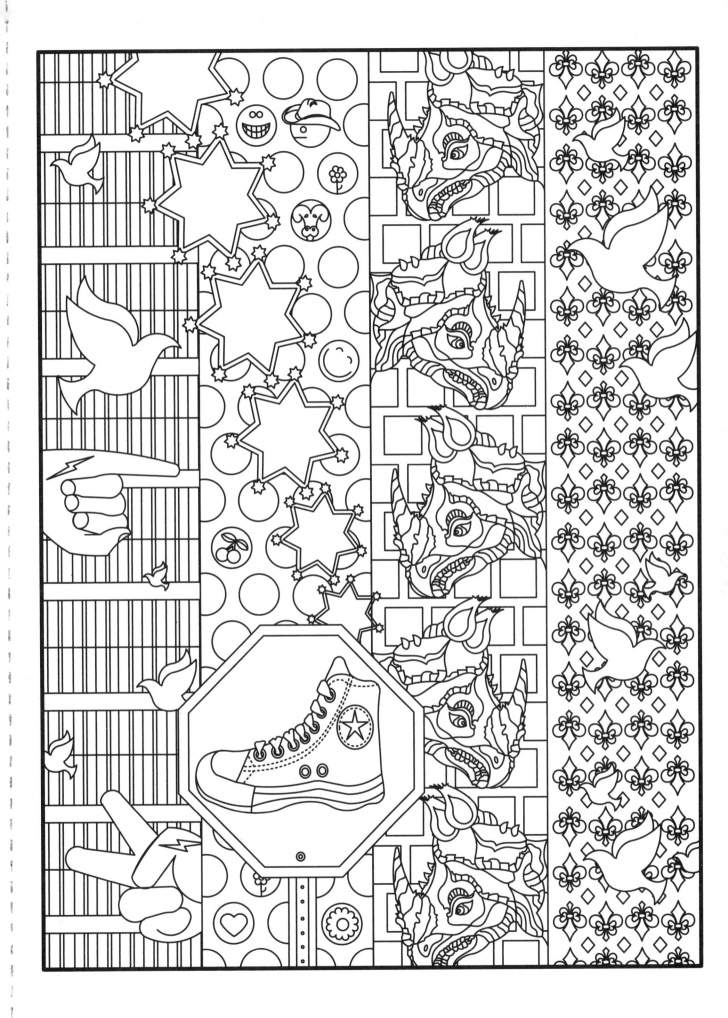

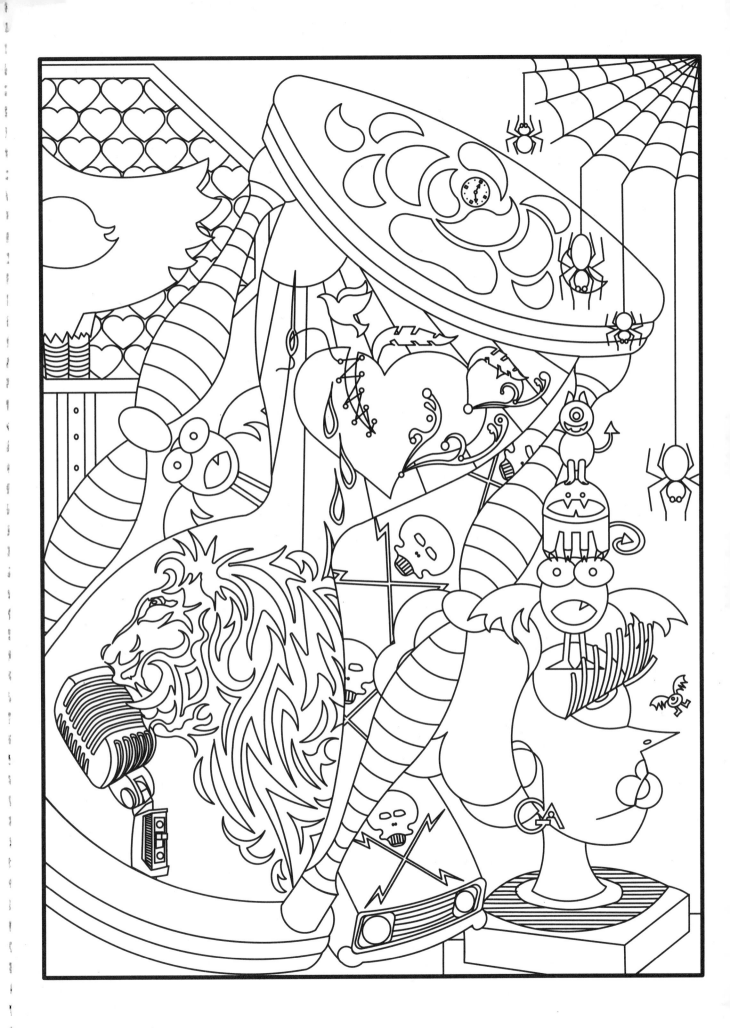

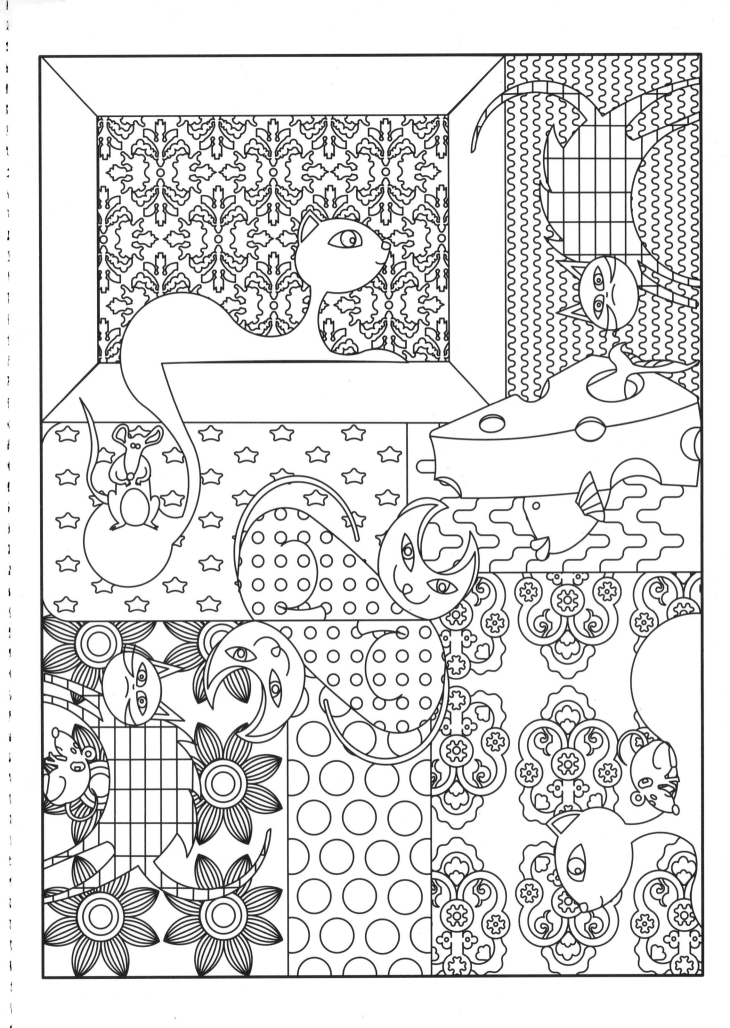

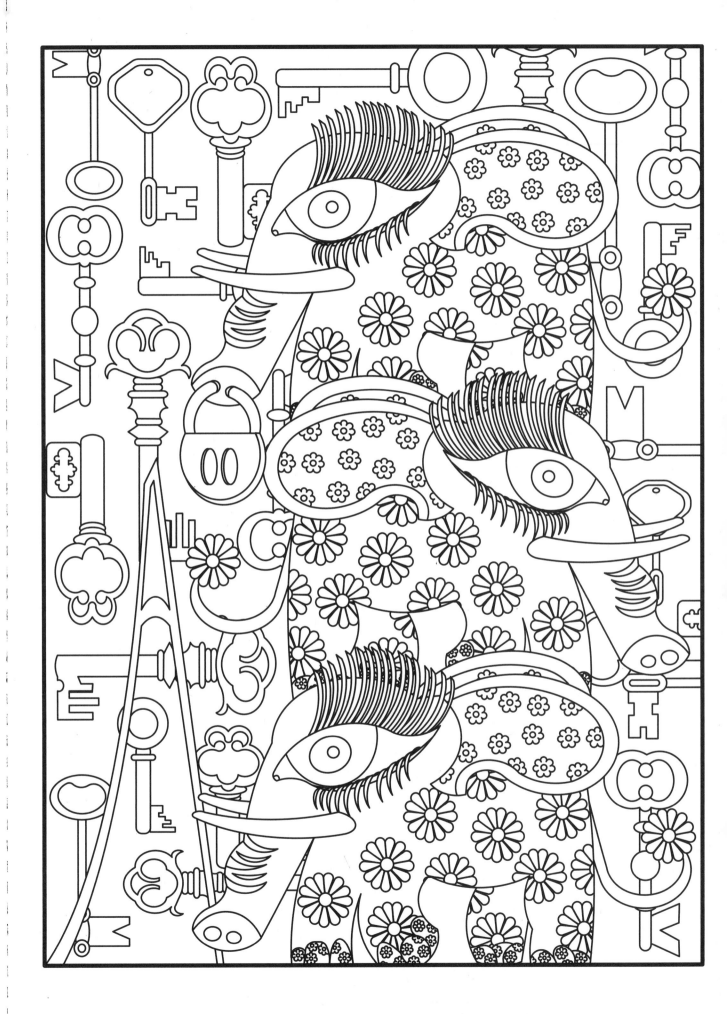

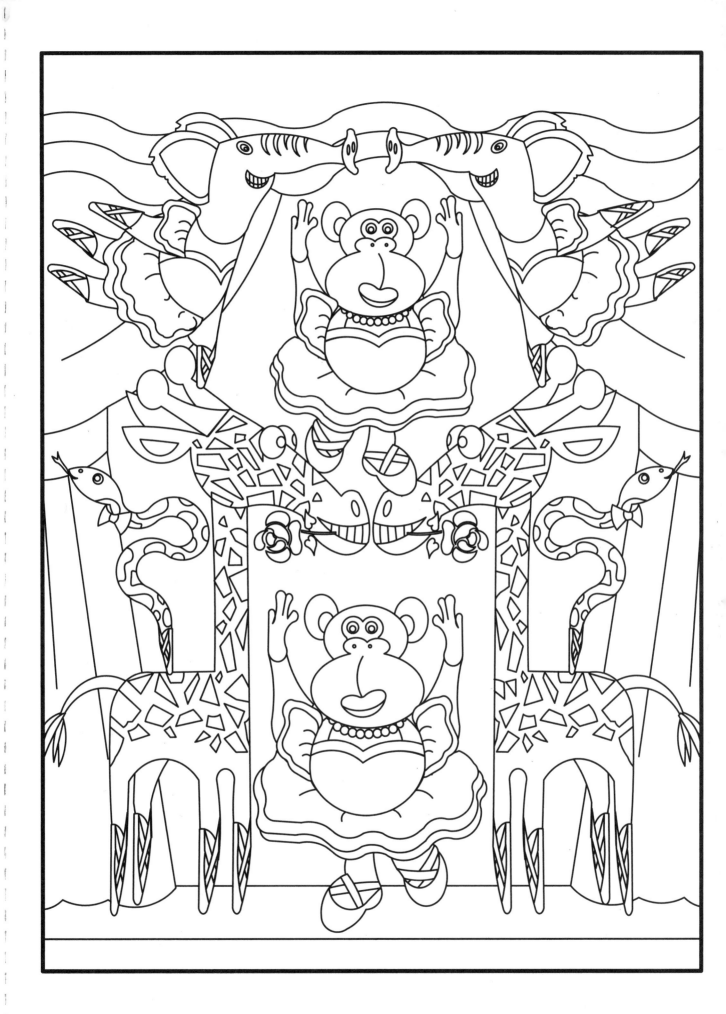

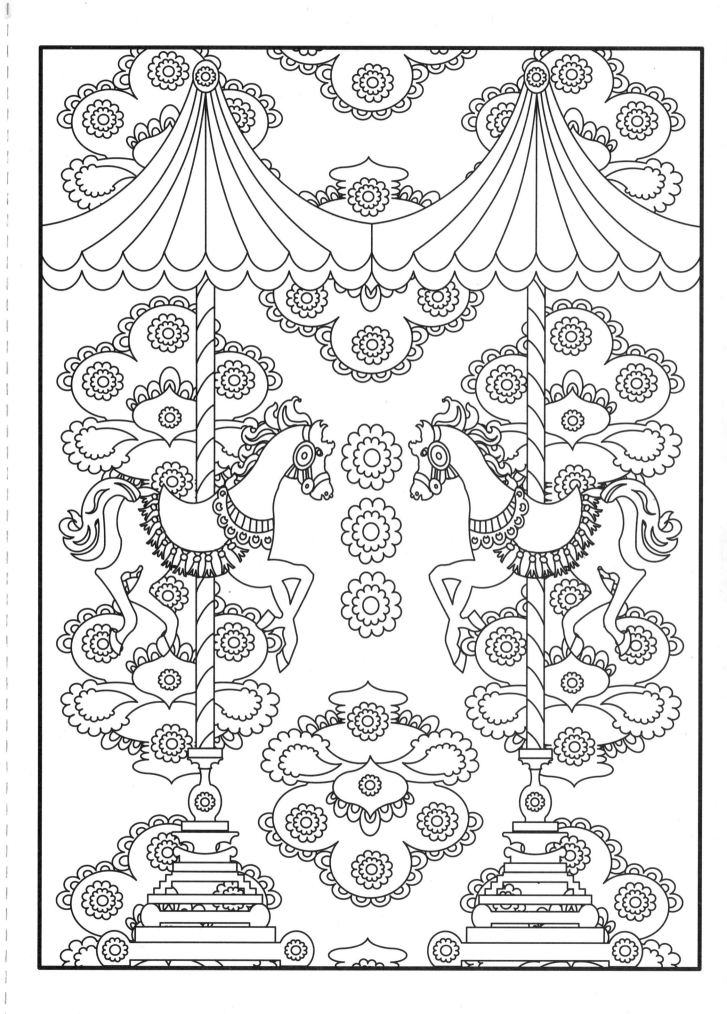

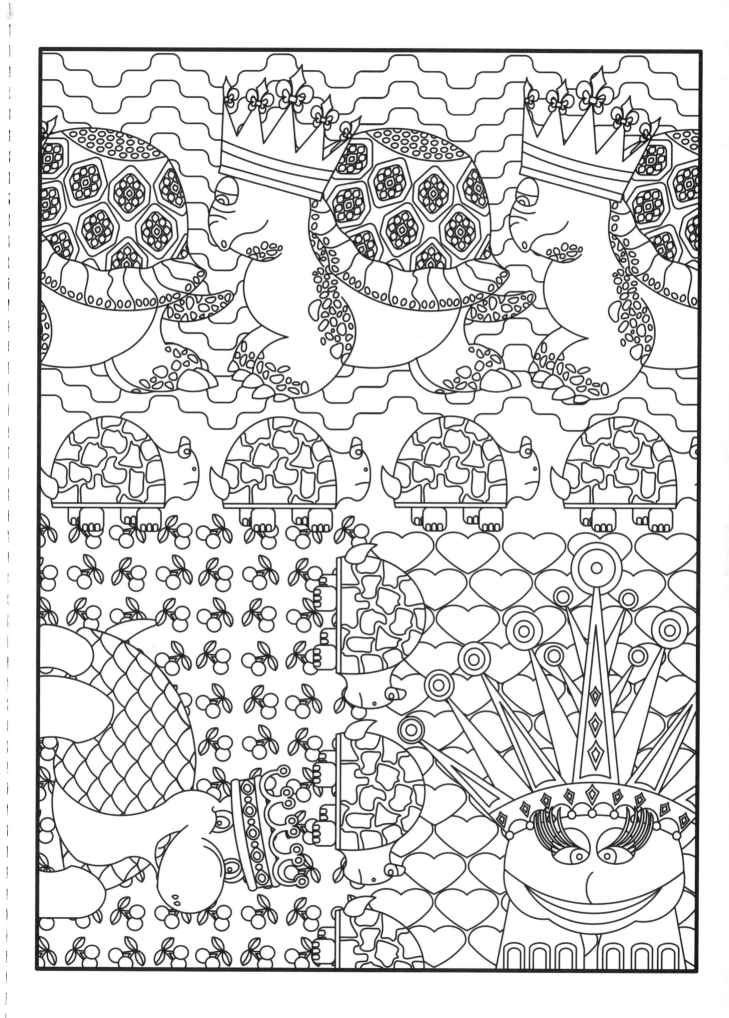

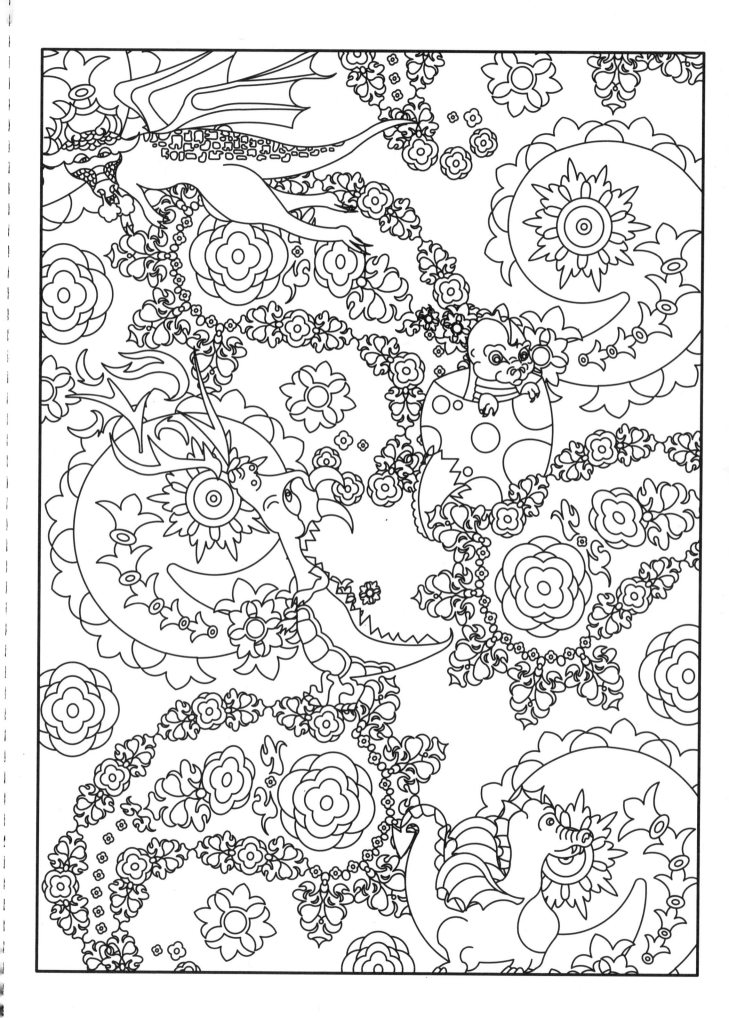

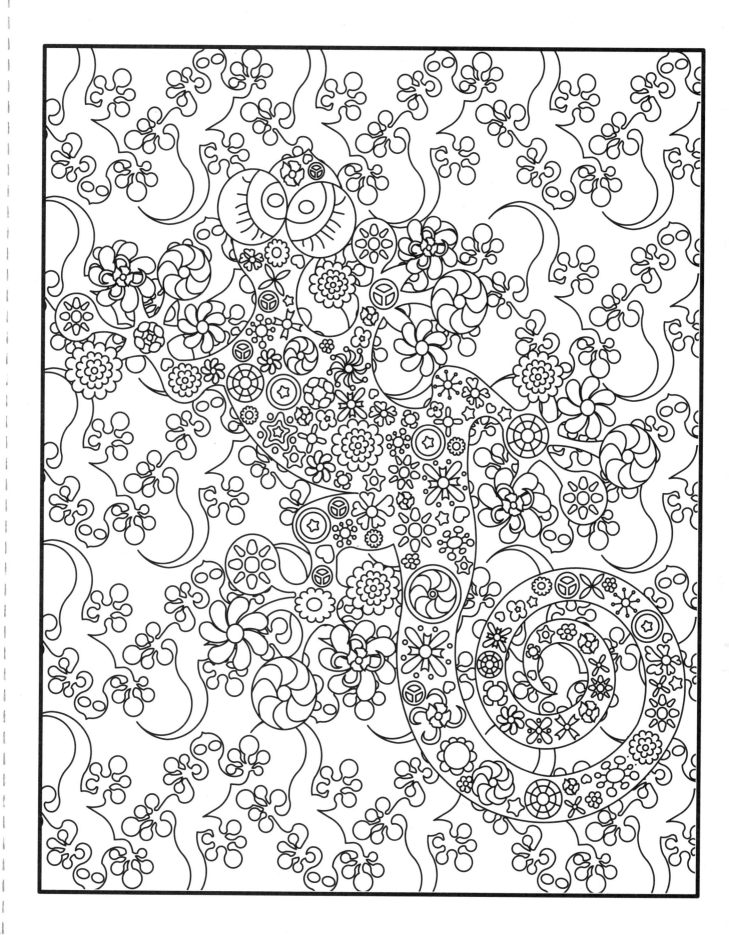

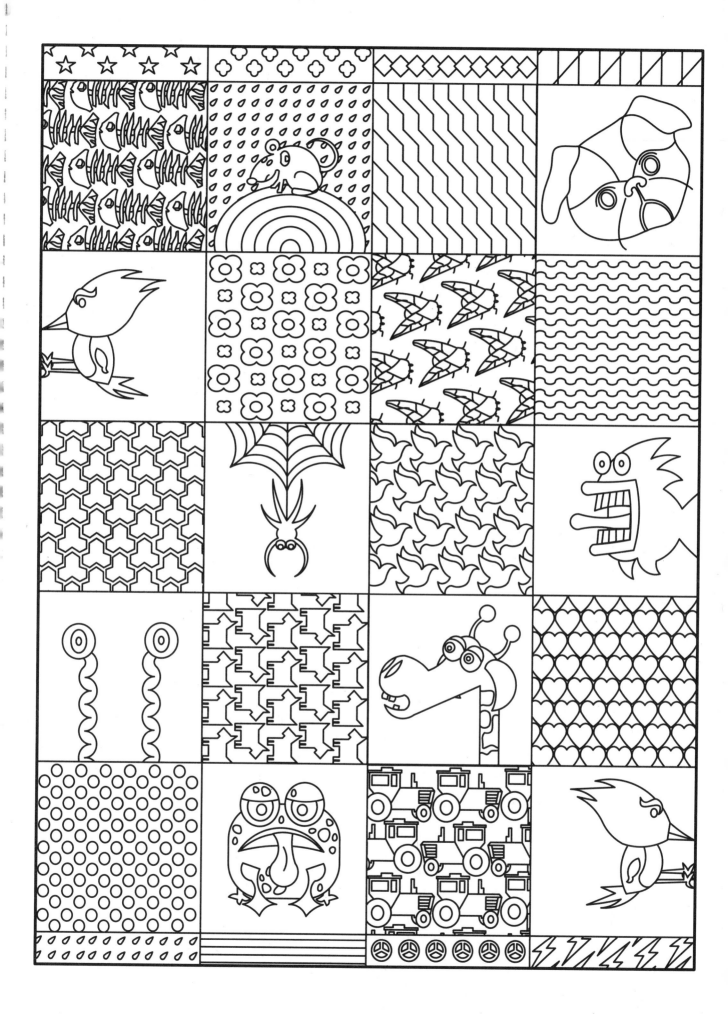

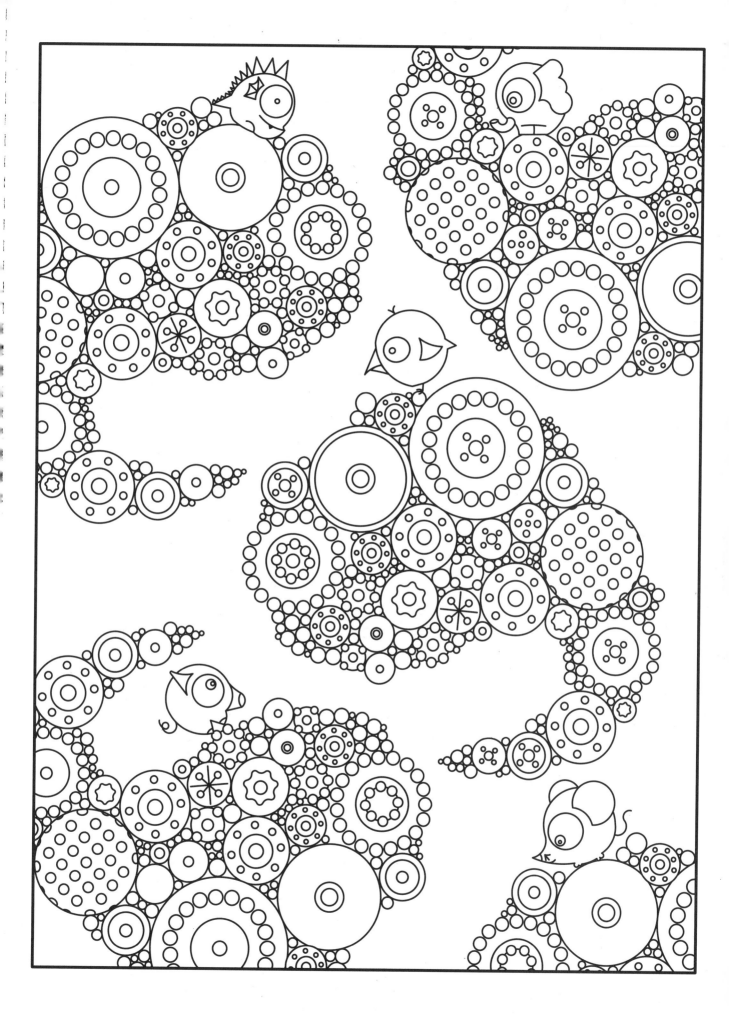

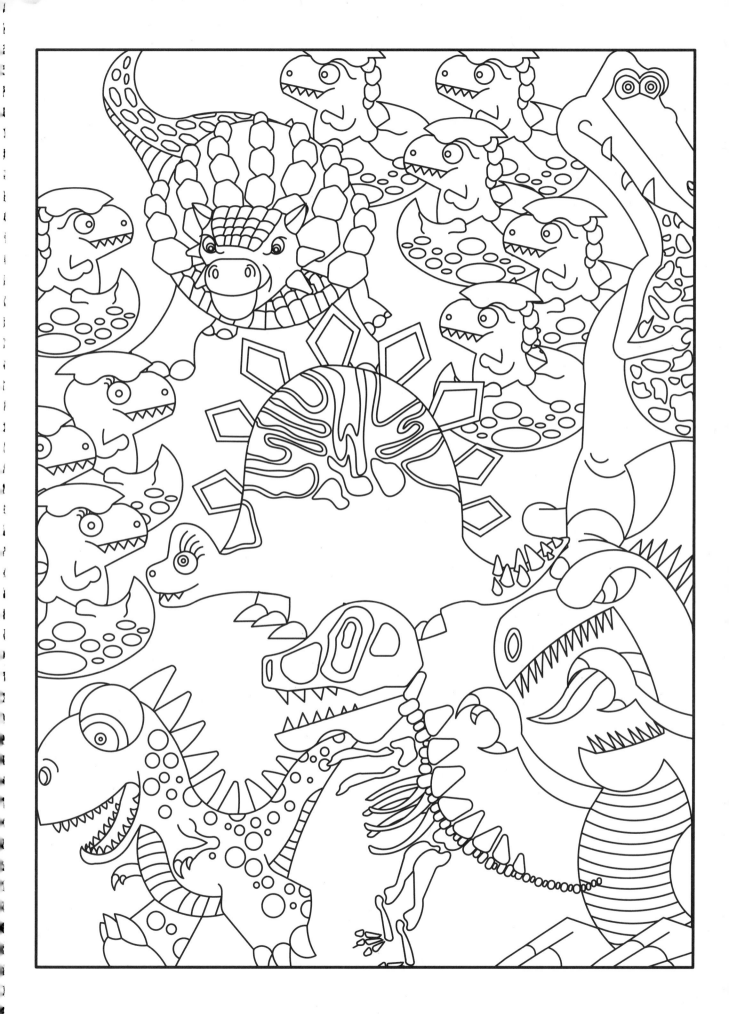

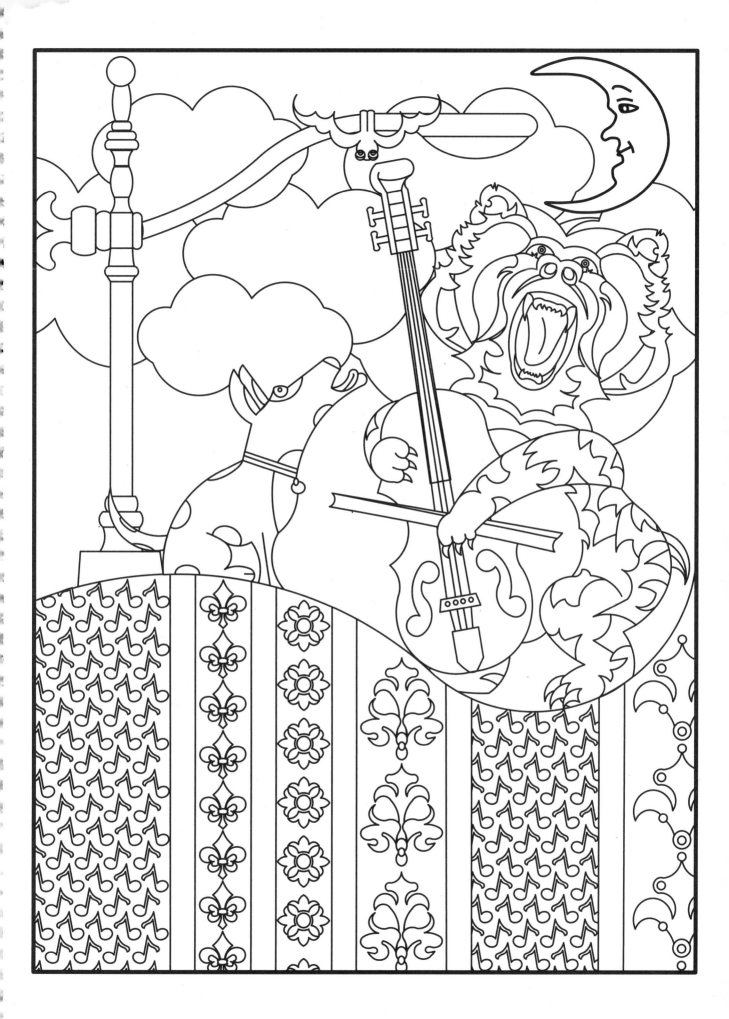

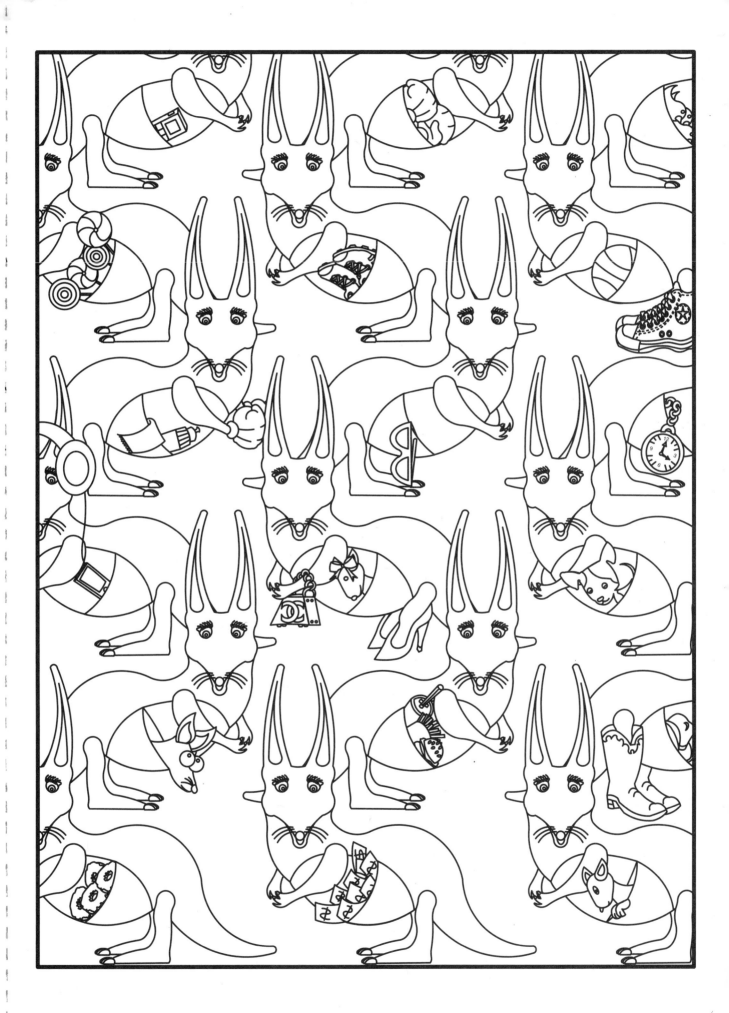

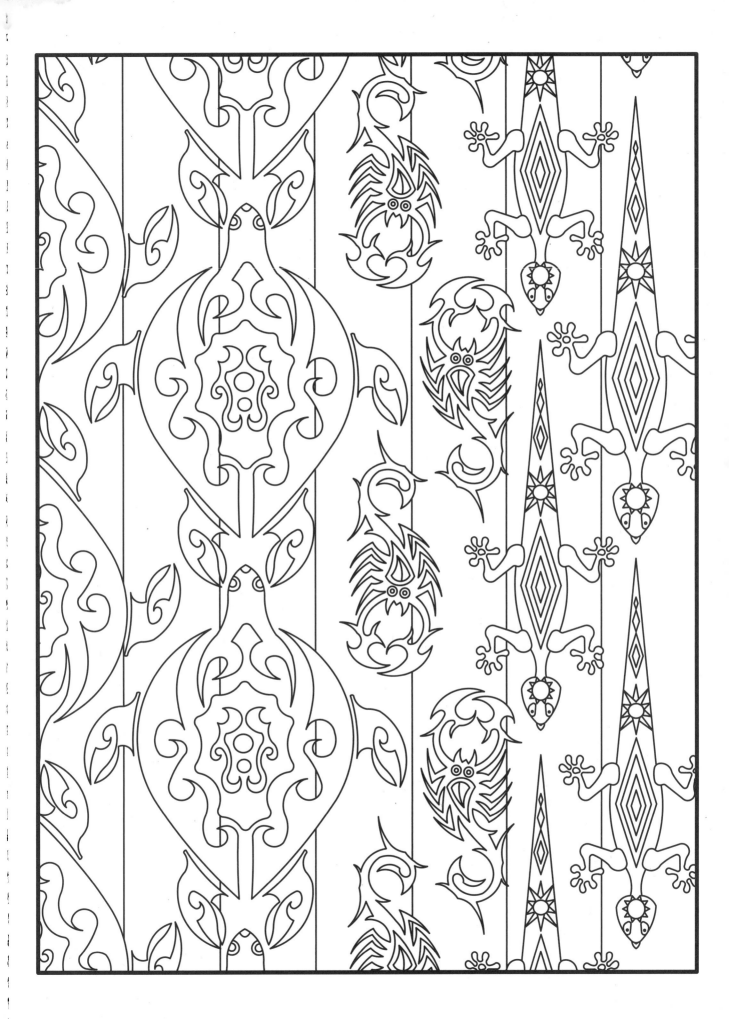

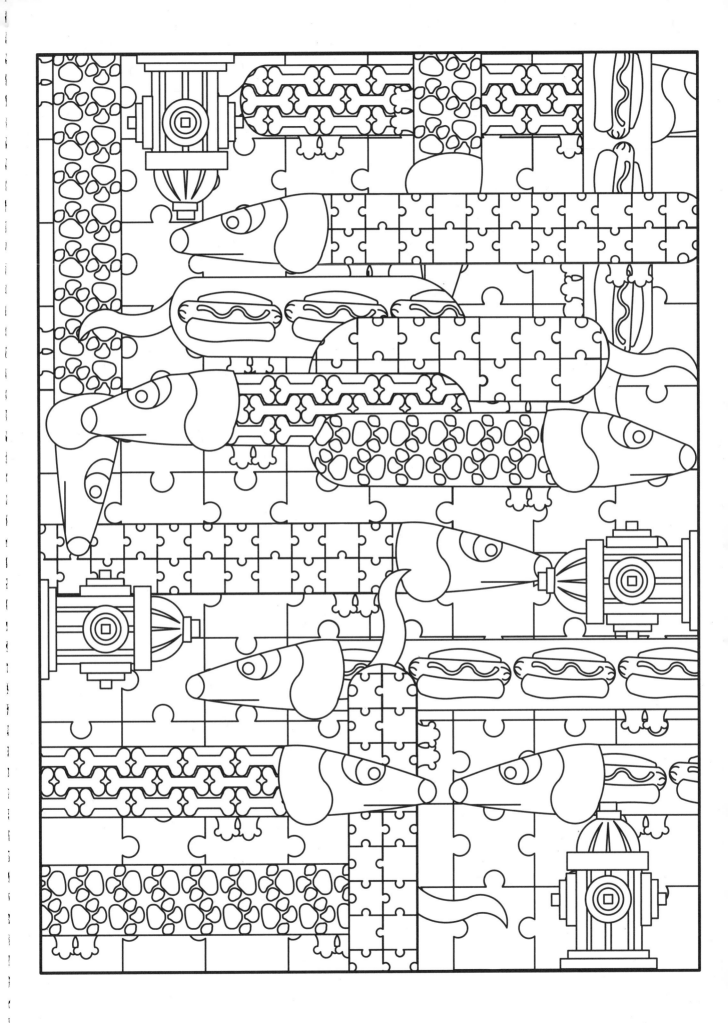

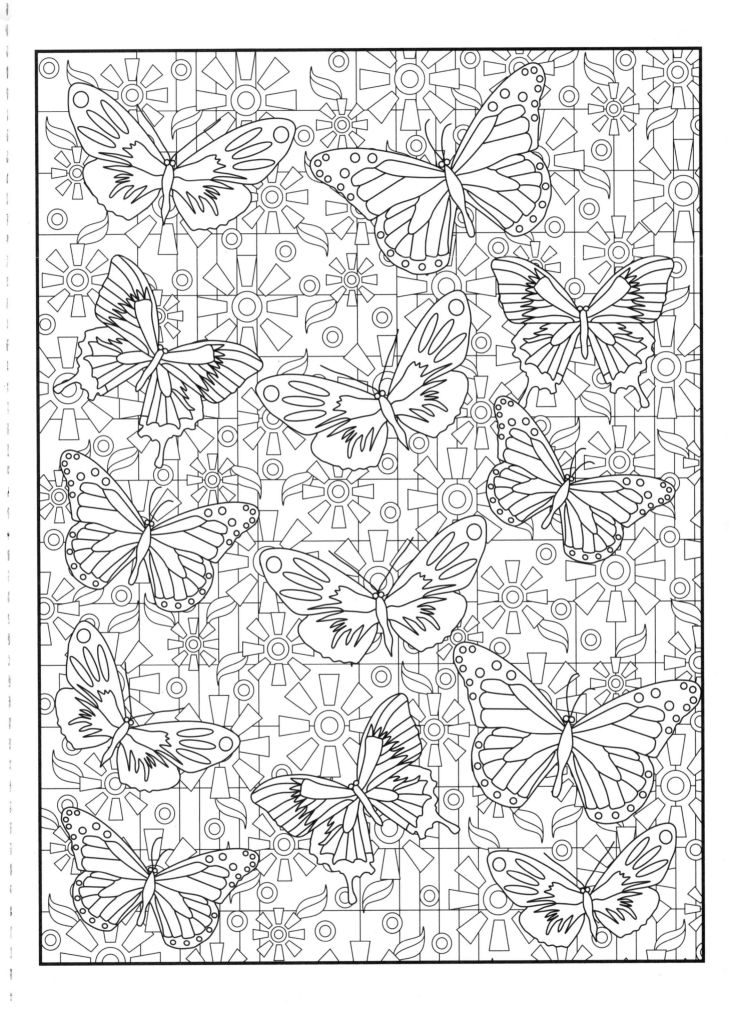

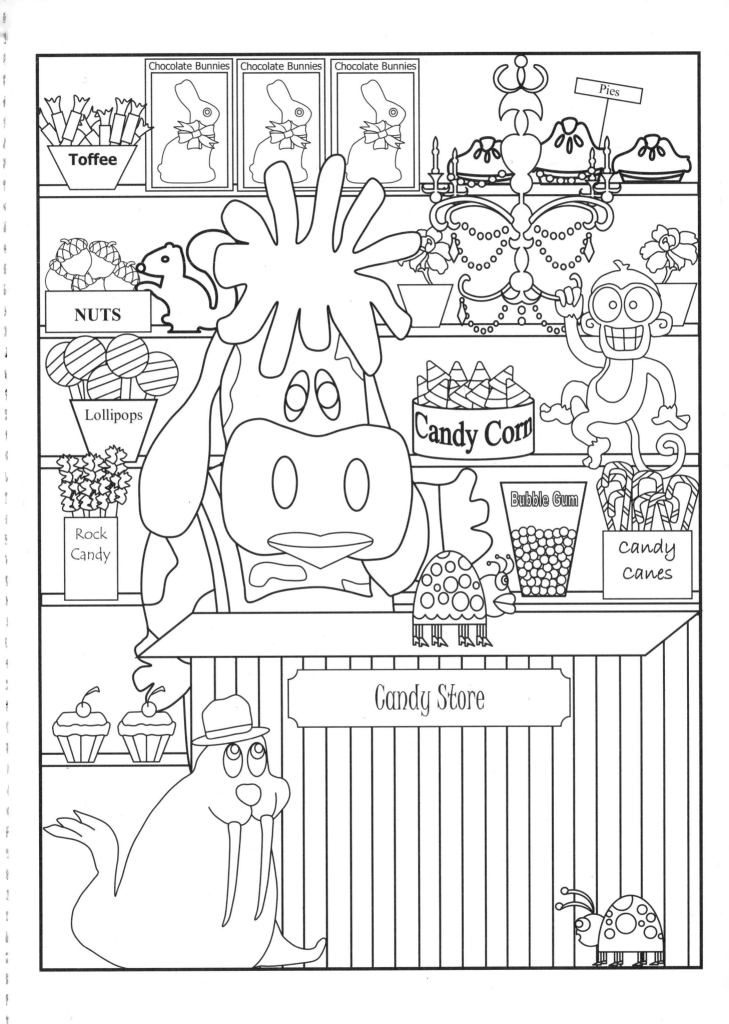

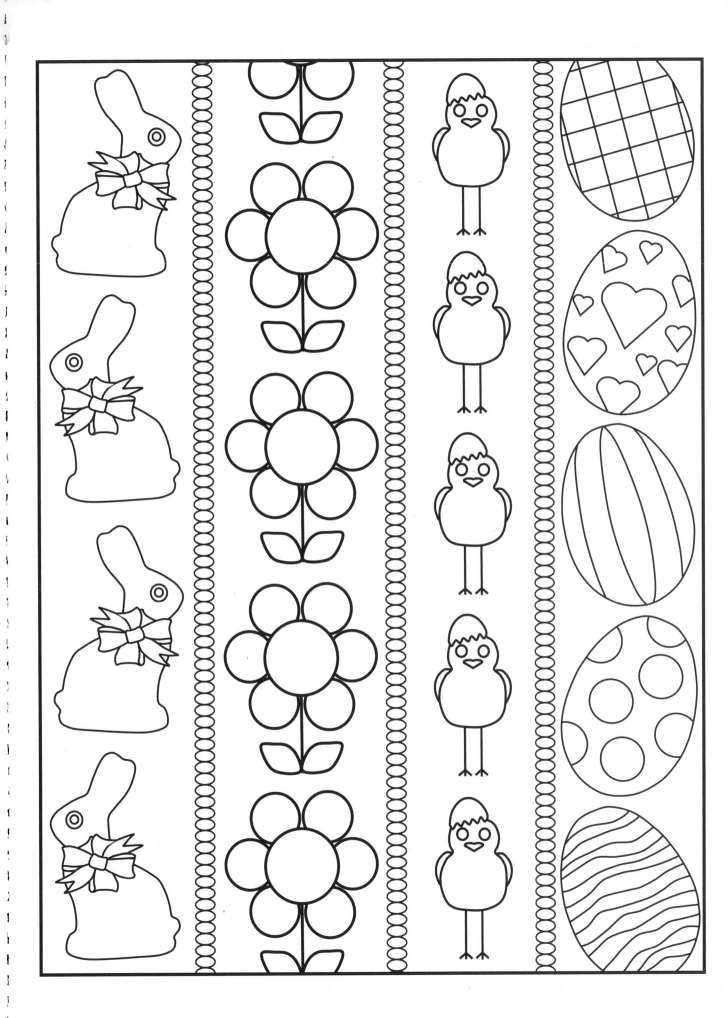

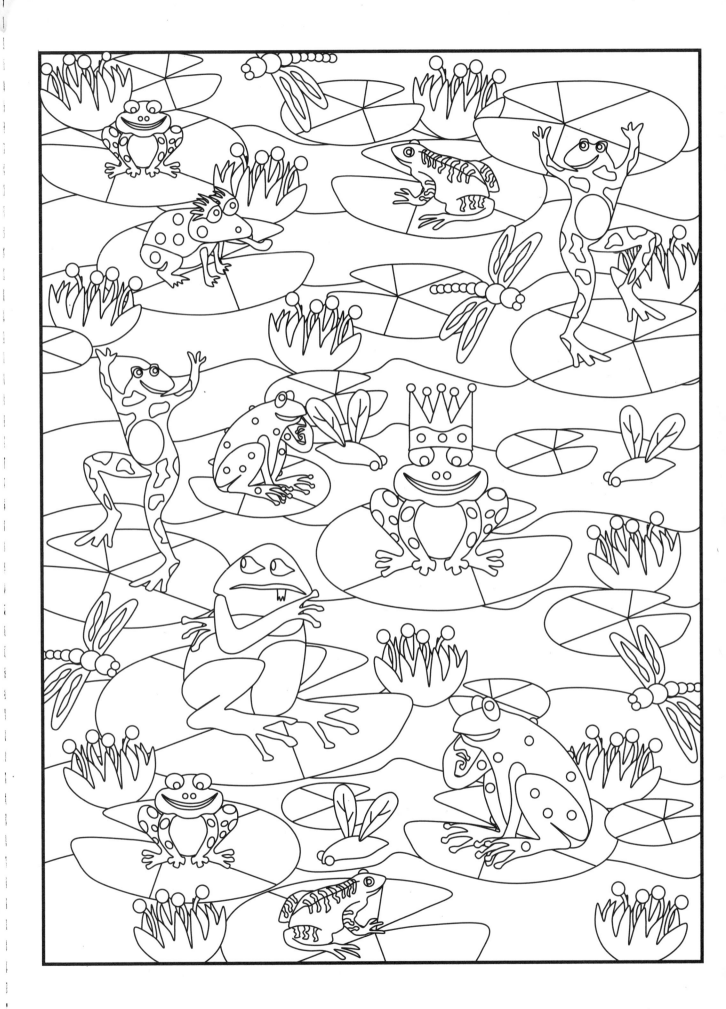

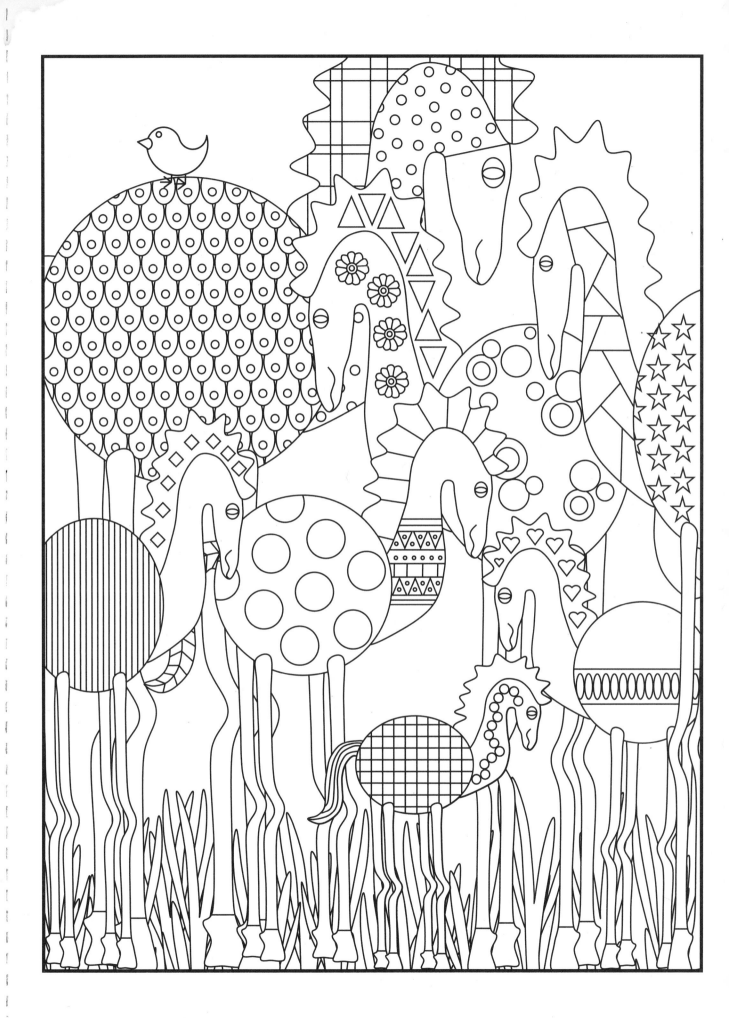

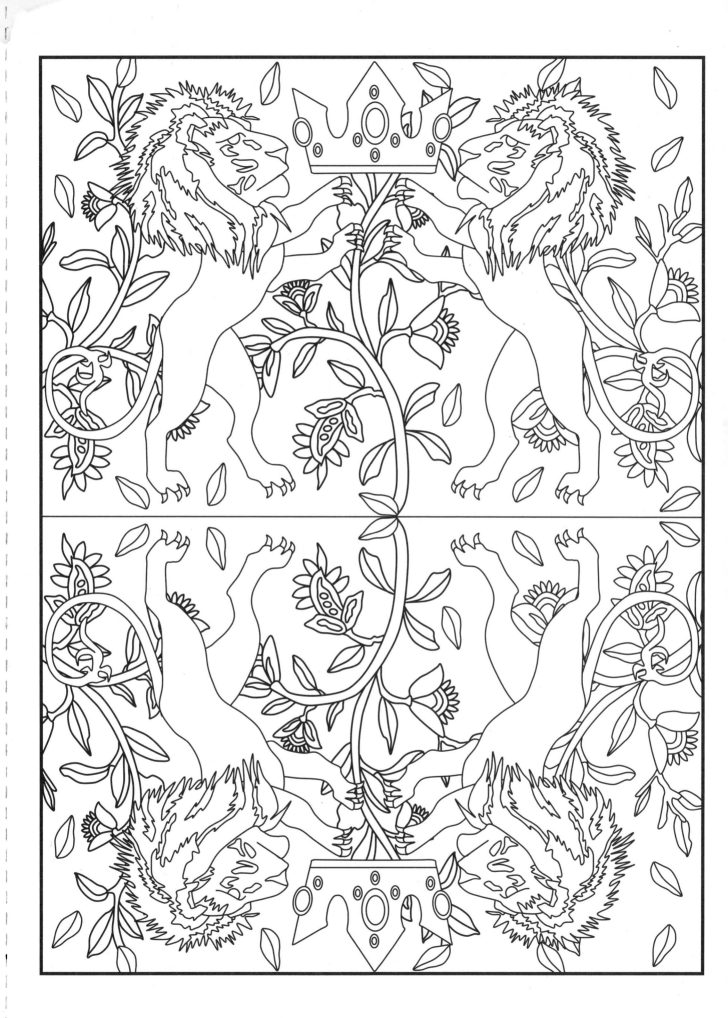

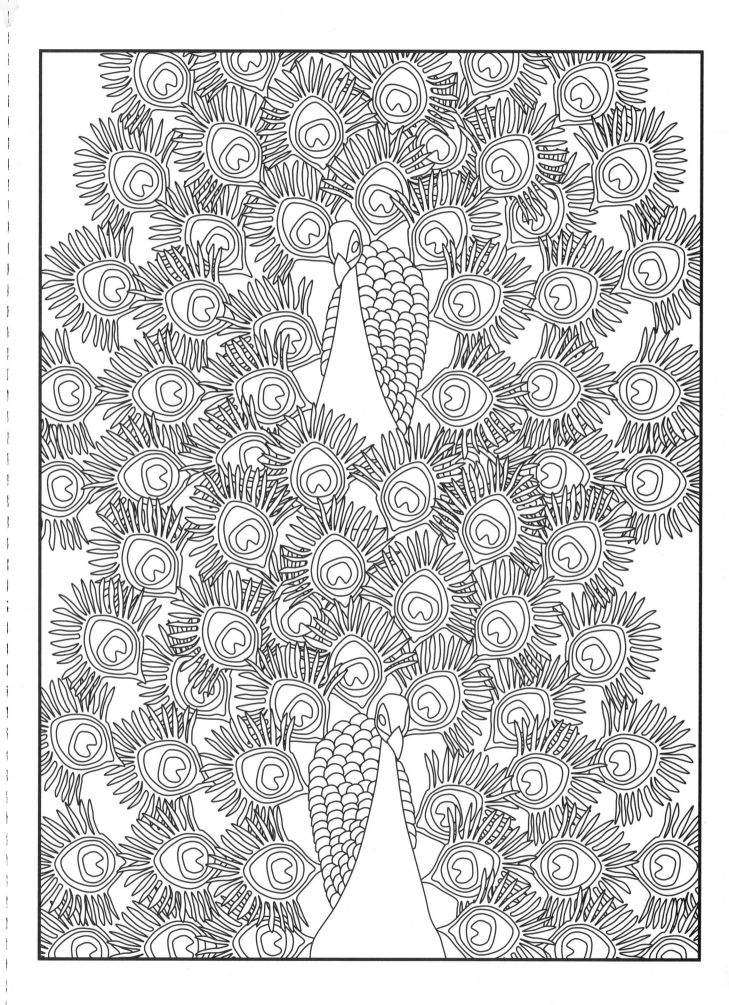

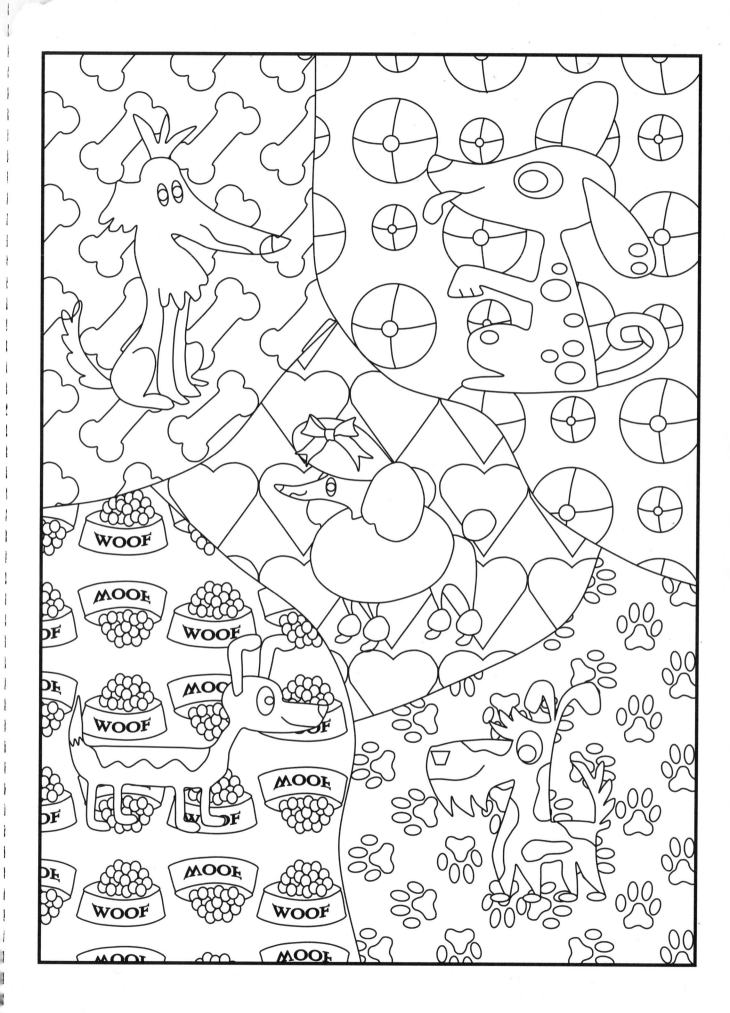

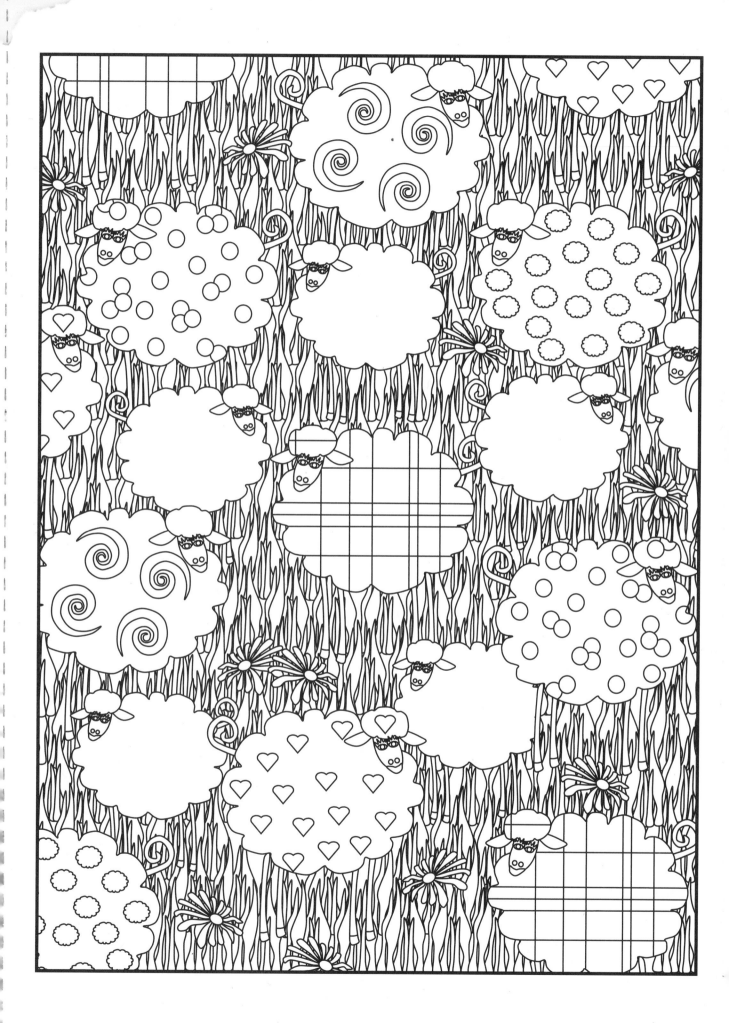

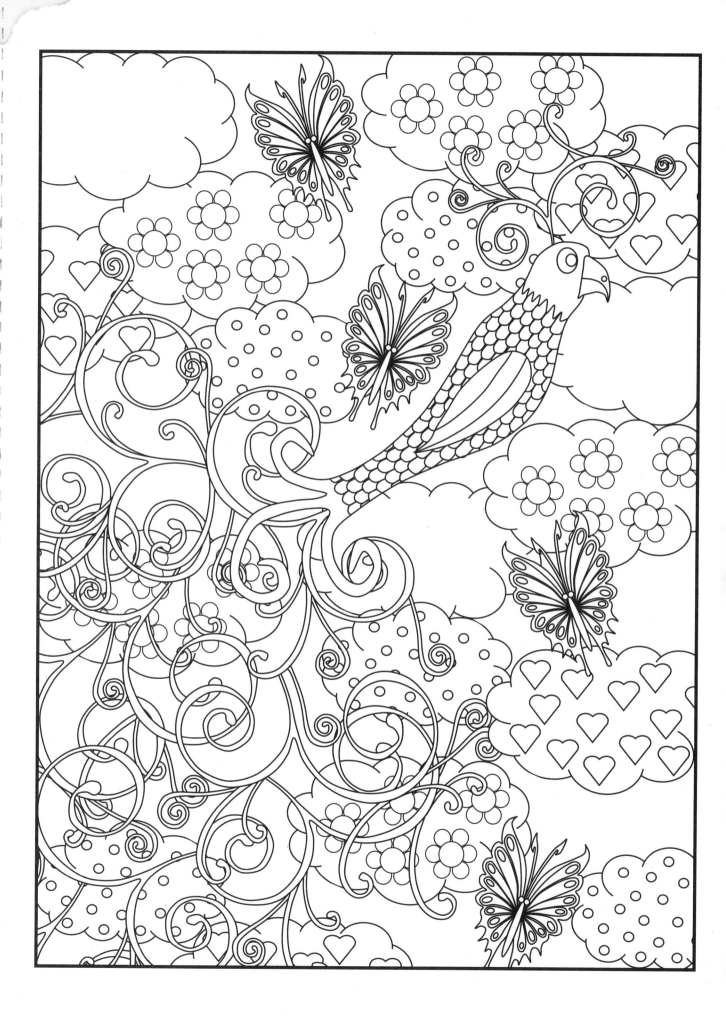

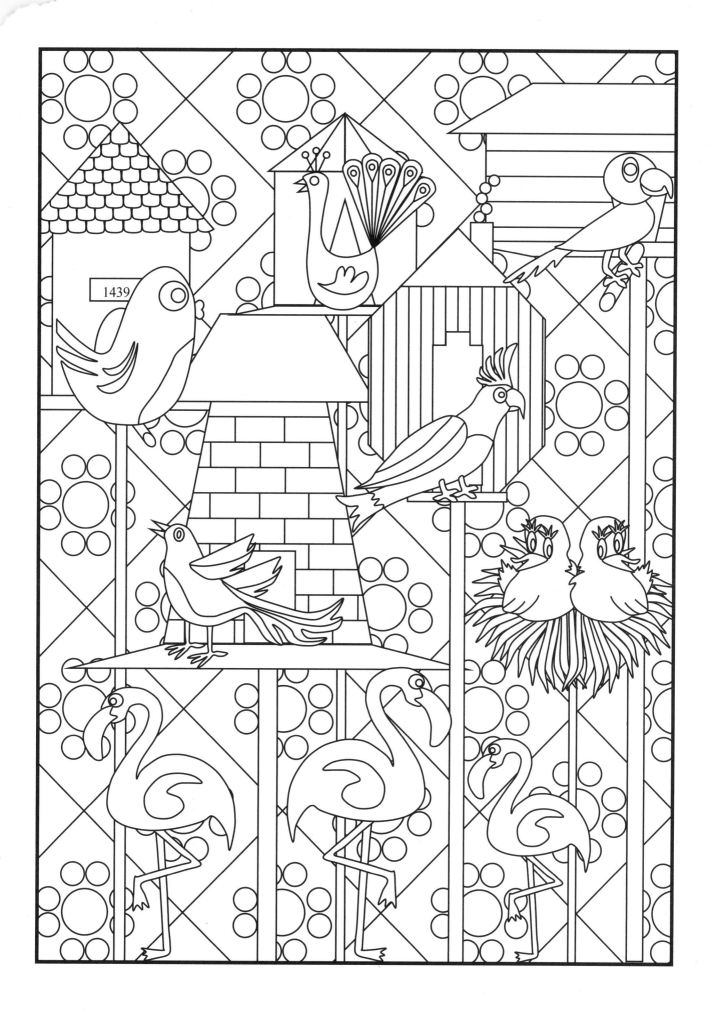